BRIDLINGTON
HISTORY TOUR

To my beautiful granddaughter, Connie

First published 2021

Amberley Publishing
The Hill, Stroud,
Gloucestershire, GL5 4EP
www.amberley-books.com

Copyright © Mike Hitches, 2021
Map contains Ordnance Survey data
© Crown copyright and database
right [2020]

The right of Mike Hitches to be
identified as the Author of this work
has been asserted in accordance with
the Copyrights, Designs and Patents
Act 1988.

ISBN 978 1 3981 0070 1 (print)
ISBN 978 1 3981 0071 8 (ebook)

British Library Cataloguing in
Publication Data.
A catalogue record for this book is
available from the British Library.

Origination by Amberley Publishing.
Printed in Great Britain.

INTRODUCTION

Bridlington today is famous as a seaside resort, thanks to the establishment of the railway from Hull, which opened in 1846 and extended a year later to link the town with Filey and Scarborough. Prior to the opening of the railway, stagecoaches would bring tourists to the town. The *British Queen* took four hours to reach the town from Hull using the coast road, terminating at the Stirling Castle Inn on the quay. Another coach, the *Wellington*, took the high road along the edge of the Wolds, via Driffield, and arrived in the Old Town at The Cross Keys Inn. When the railway arrived the station was built halfway between the quay and the Old Town business district, much to the inconvenience of holidaymakers who wanted to be nearer the quay area.

The town's history, however, dates back as far as AD 400 when the area was occupied by the Romans. Between then and the Norman Conquest Bridlington had several other names: Bretlingto, Brillinton, Breddelinton, Burlington (used until the nineteenth century) and Bollinton. Roman roads and villas can be found nearby and near Sewerby (just north of Bridlington) an Anglican cemetery marks the spot where the Viking King Ida landed in AD 57.

The town's harbour probably dates back to prehistoric times and trade routes have converged on the area from that period. Irish gold was traded across the Pennines to Jutland, now modern Denmark, via Bridlington using existing roads, including Roman roads such as Woldgate.

After the Battle of Hastings in 1066 William the Conqueror confiscated the manor of Bridlington and granted it to Gilbert de Gaunt in 1113; the harbour was granted to the Prior of Bridlington. In the same year Walter de Gaunt founded the monastery and Church of St Mary, which is now Bridlington Priory.

The priory was granted the right to hold a fair and market in 1200. High Green was the location of the fair and it may well have hosted the market before it moved to the Market Place at the far end of Old Town.

Old Town itself probably dates back to the establishment of the priory and is nowadays more famous for its narrow streets and the Georgian façades of its buildings. Some of these frontages also contain priory stone taken after the dissolution and destruction of the monastery during the reign of Henry VIII. Old Town and the more modern Bridlington, established around the quay and harbour, were separate for some time. Old Town was the business and trading centre, while the area around the quay was largely involved with the fishing industry along with the import and export of goods. Some 300 fishing vessels were using North Pier in 1902, eighty-four of which were Bridlington based. The Scottish fishing fleet would often call at the harbour, with as many as 100 vessels at the port on August Sundays.

After the coming of the railway building expanded rapidly to cater for the growth of the holiday trade. To cater for the demands of tourism, attractions were built, including the Victoria Rooms on the North Pier and the New Spa (which burned down several times) and the People's Palace, along with the Floral Hall. Most of these structures have since disappeared, being replaced by more modern entertainments.

KEY

1. Cross Street
2. Bridlington Spa
3. South Side
4. The Harbour
5. The Esplanade
6. The Grand Pavilion and Floral Hall
7. Leisure World
8. Trinity Church and Cut
9. The Promenade
10. Princes Street
11. Quay Road
12. Christ Church
13. Bridlington Railway Station
14. Lloyd Hospital
15. Bridlington Priory
16. The Bayle Gate
17. Kirkgate
18. The Old Town
19. Market Place
20. Ye Olde Star Inn
21. The Avenue

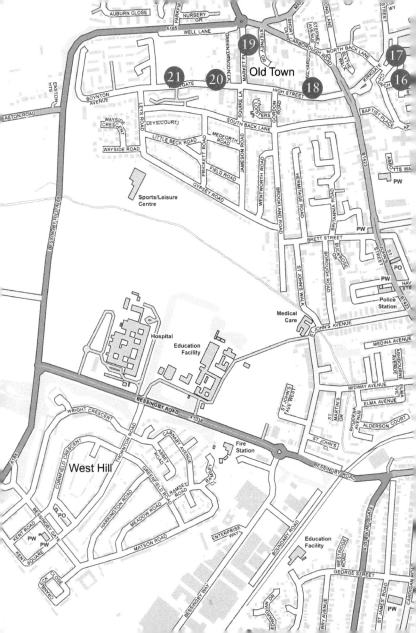

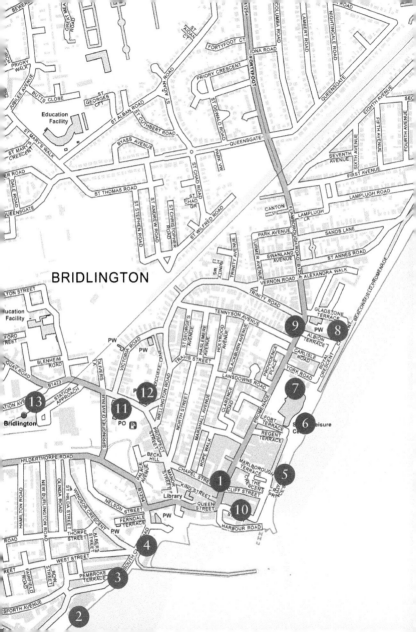

BRIDLINGTON

1. CROSS STREET

Before the bus station was opened behind The Promenades Shopping Centre, buses terminated in Cross Street. In this image from the 1950s there is an East Yorkshire Motor Services AEC Regent bus in the company's dark blue with cream bands on a service to Driffield. The company usually operated Leyland vehicles, so this is an unusual sight. Modern EYMS buses are in a maroon and cream livery. Also in view is a 'Bristol' single-deck bus bound for Leeds.

2. BRIDLINGTON SPA

Seen from South Marine Drive, the (New) Spa is seen on South Side in the 1930s. Work on the South Bay commenced in 1894 when the Spa and Garden Company started building work here. The original spa was destroyed by fire in 1906, then rebuilt the following year and extended between 1926 and 1928. This building was also destroyed by fire and was rebuilt in the art deco style as the New Spa in 1932. The spa was taken over by East Yorkshire County Council in the 1990s and was reopened in 1996.

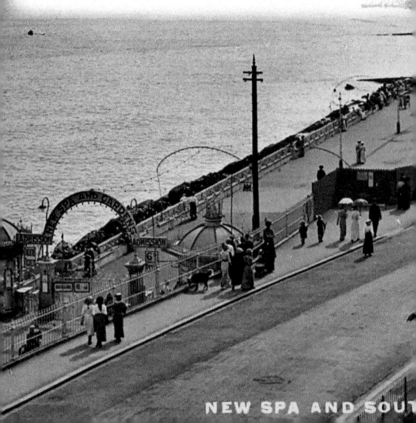

NEW SPA AND SOUT

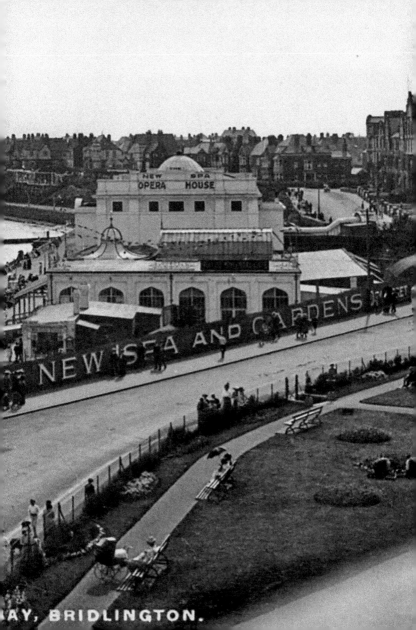

NEW SPA
OPERA HOUSE

NEW SPA AND GARDENS

...AY, BRIDLINGTON.

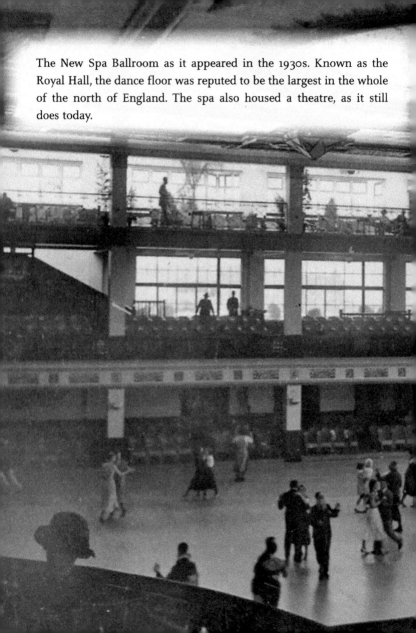

The New Spa Ballroom as it appeared in the 1930s. Known as the Royal Hall, the dance floor was reputed to be the largest in the whole of the north of England. The spa also housed a theatre, as it still does today.

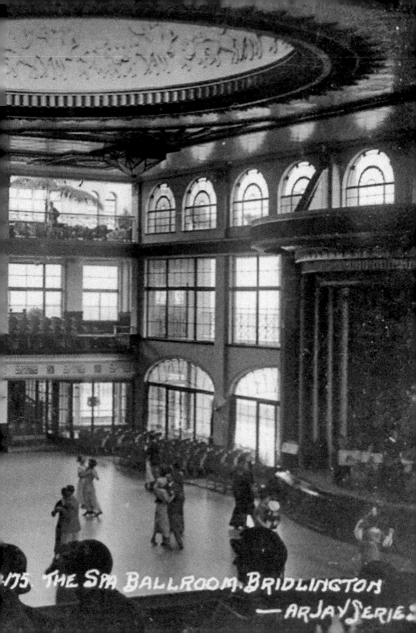

175. THE SPA BALLROOM. BRIDLINGTON
—ARJAY SERIES

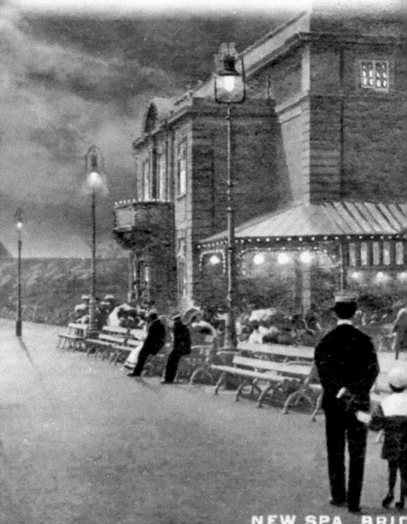

An Edwardian view of the original spa building, seen from the South Promenade on a moonlit summer's evening.

NEW SPA, BRID
(BY NIG

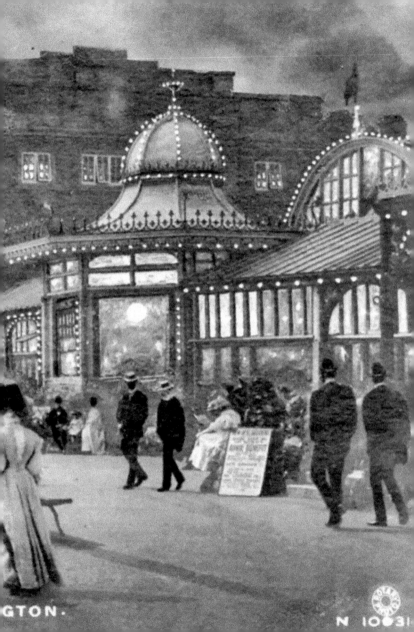

The New Spa also had a solarium, which tried to create a desert island feel with palm trees among the basket weave tables and chairs. The solarium was well patronised during wet summer days in the 1920s.

70.176. THE SOLARIUM. S

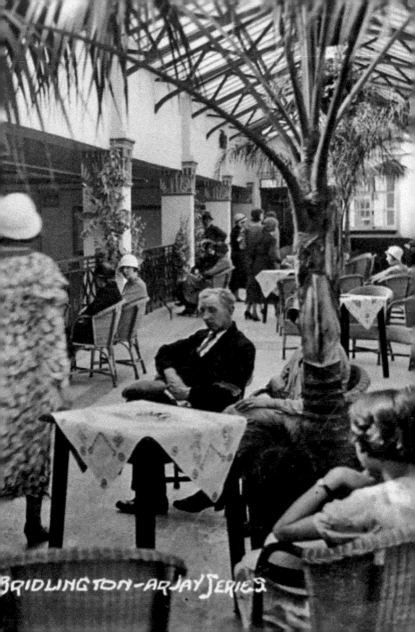

BRIDLINGTON-ARJAY SERIES

3. SOUTH SIDE

An early twentieth-century view of the promenade at the south side of Bridlington with the harbour in the background.

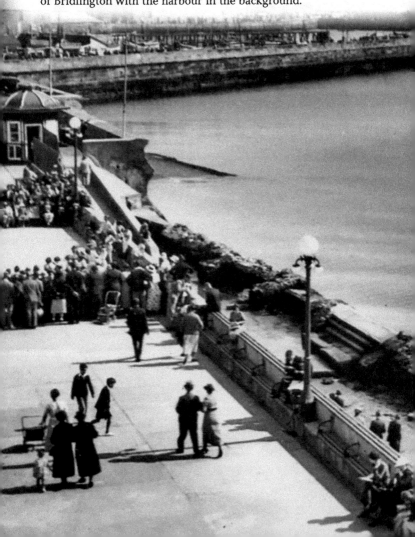

Spa Promenade and Harbour, Bridlington

Looking south beyond the spa building is the boating lake and housing above. This view shows a very busy beach in the 1950s.

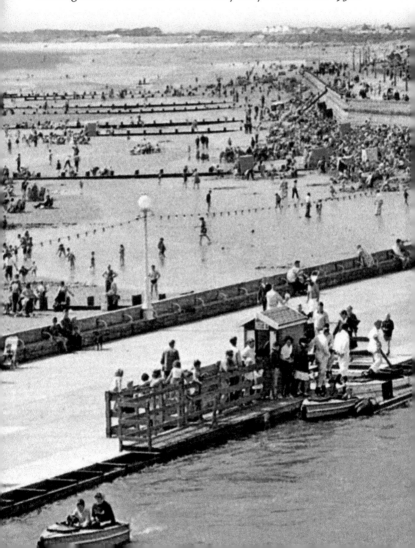

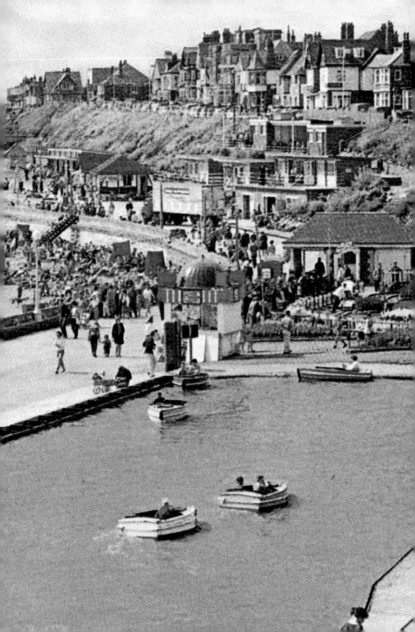

4. THE HARBOUR

The harbour at Bridlington developed from a small fishing port in the seventeenth century and became known as Bridlington Quay. Along with fishing, trade developed with exports of barley, corn, malt and Bridlington beer. Trade to the Baltic was also important and the harbour needed further development. In the nineteenth century, John Rennie surveyed the harbour and work began on stone piers. By 1848, both the north and south piers had been constructed.

The harbour at Bridlington as it appeared in the eighteenth century, with sailing ships departing for the fishing grounds. At this time there was very little development in the town. The discovery of a chalybeate spring allowed a rapid growth in tourism and the town expanded to meet this new market.

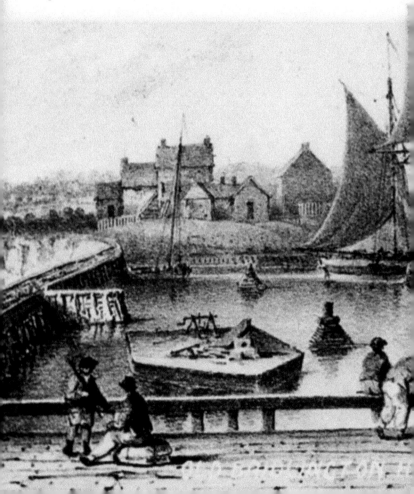

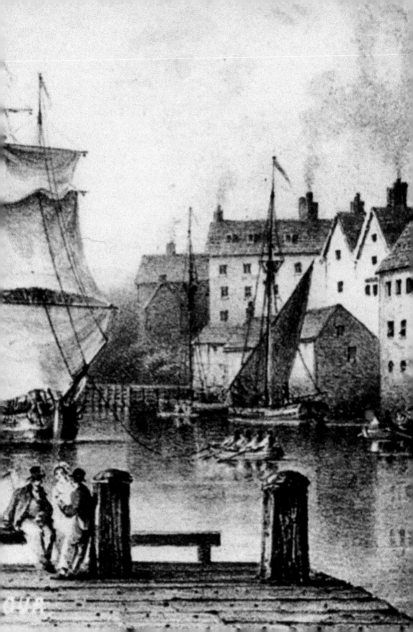

A general view of the North Pier at the harbour in the late nineteenth century, with a glimpse of the expanding town beyond.

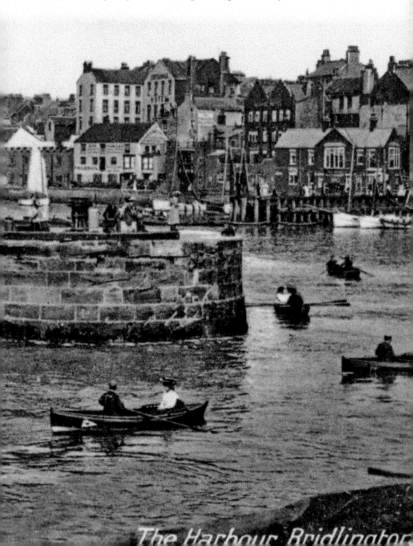

The Harbour Bridlington

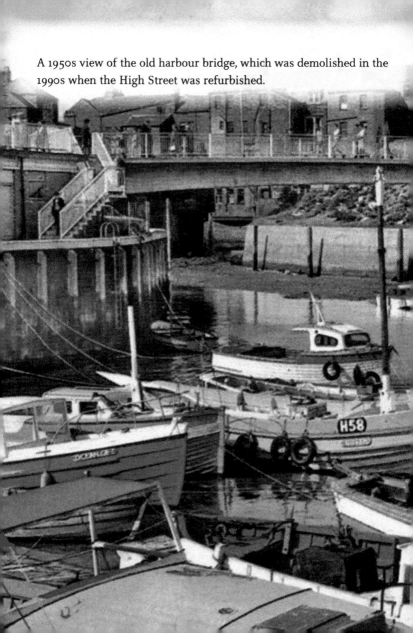

A 1950s view of the old harbour bridge, which was demolished in the 1990s when the High Street was refurbished.

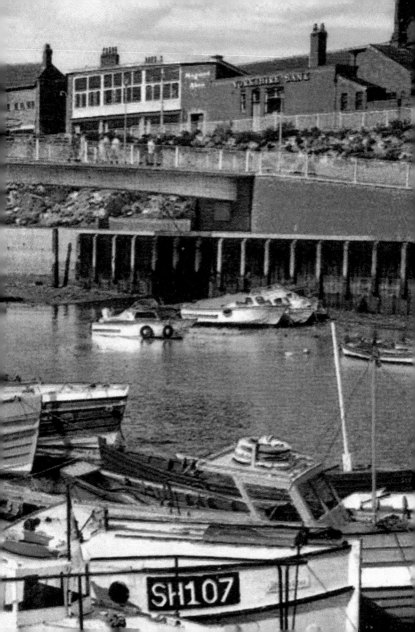

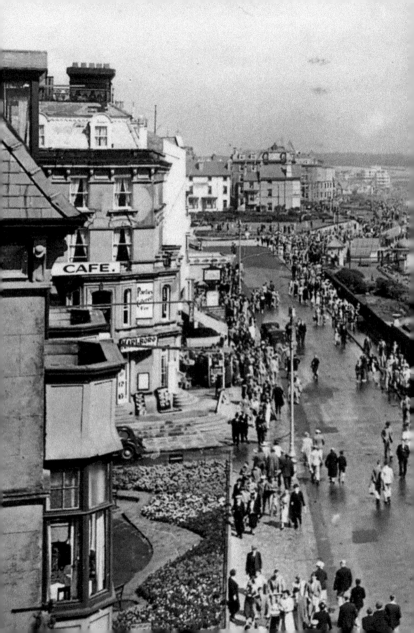

5. THE ESPLANADE

The Esplanade, on the south shore, is seen here on a very busy summer's day in the 1930s, giving an idea of just how busy Bridlington was at this time. The town remained popular right up until the 1960s when the advent of cheap package holidays in sunny foreign locations changed summer holiday habits.

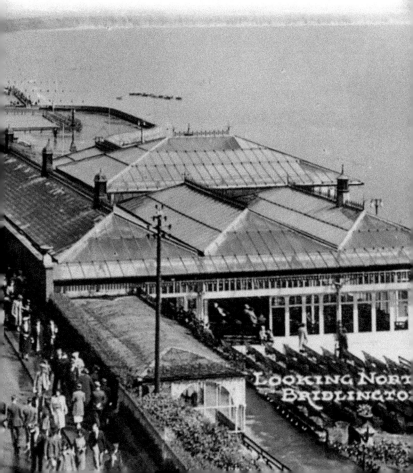

LOOKING NORT
BRIDLINGTO

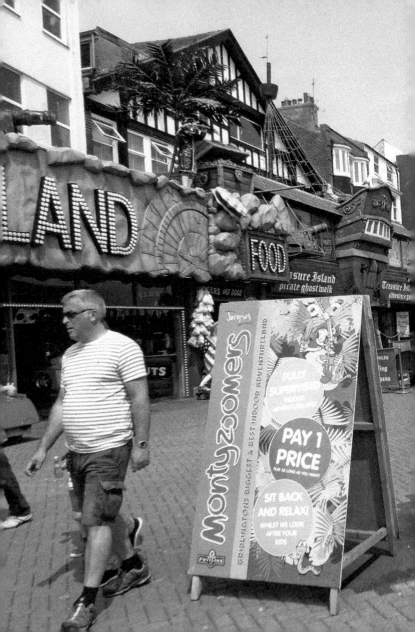

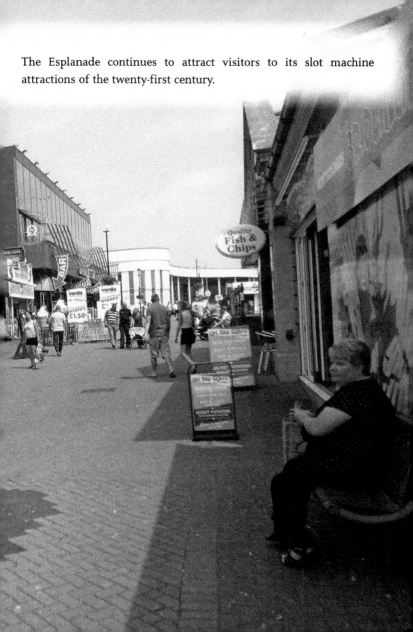

The Esplanade continues to attract visitors to its slot machine attractions of the twenty-first century.

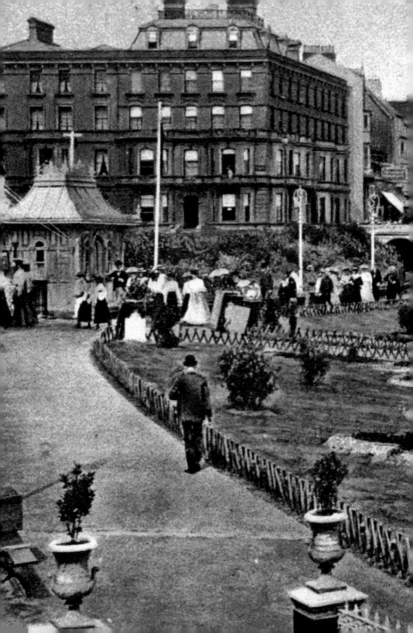

6. THE GRAND PAVILION AND FLORAL HALL

Princes Parade, seen here during the Edwardian period, was where the Grand Pavilion and Floral Hall were situated. The Grand Pavilion was built in 1906, as was the Floral Hall, with floral displays in front. The Grand Pavilion survived until 1936 when it was demolished. The 'Pavilion' name has survived as a seafront café and bar now uses it.

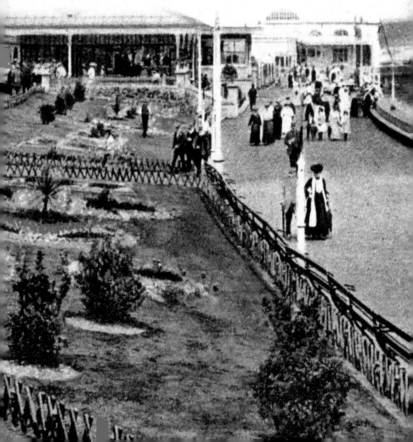

The floral clock is seen sitting in front of the Floral Hall in this view, along with the floral garden. Since then times have changed: the Floral Hall has long gone and the clock was moved to nearby Sewerby Hall.

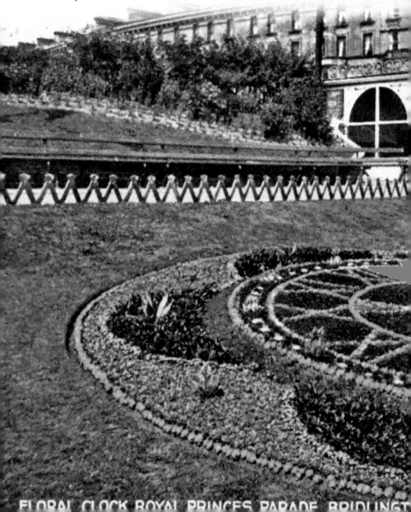

FLORAL CLOCK ROYAL PRINCES PARADE BRIDLINGT

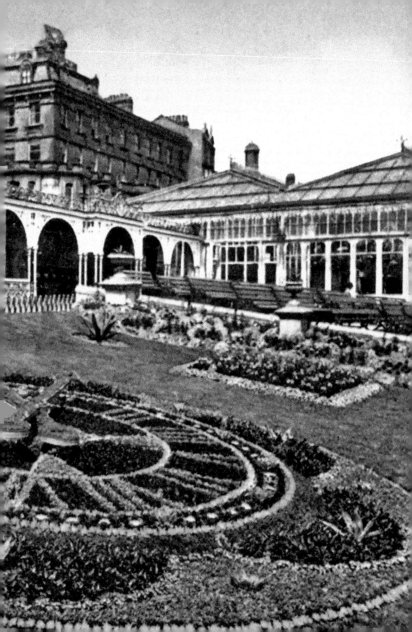

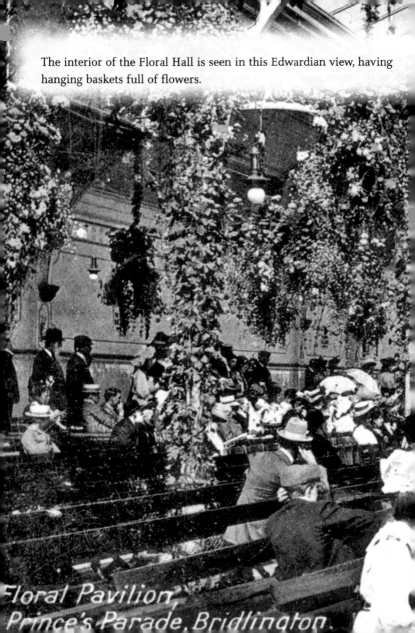

The interior of the Floral Hall is seen in this Edwardian view, having hanging baskets full of flowers.

Floral Pavilion,
Prince's Parade, Bridlington

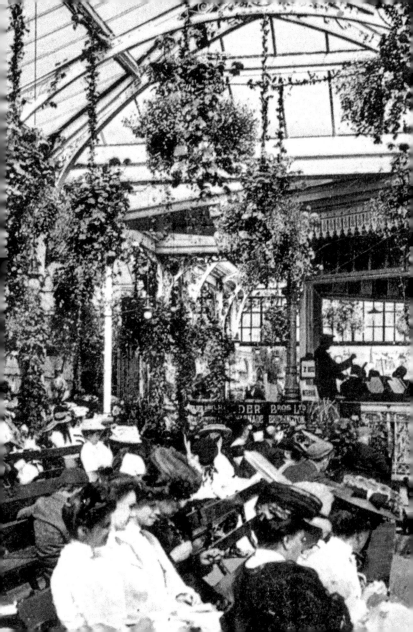

Another feature was the floral staircase, which led up above the Floral Hall. A floral carpet was also situated outside the hall and must have looked spectacular at that time.

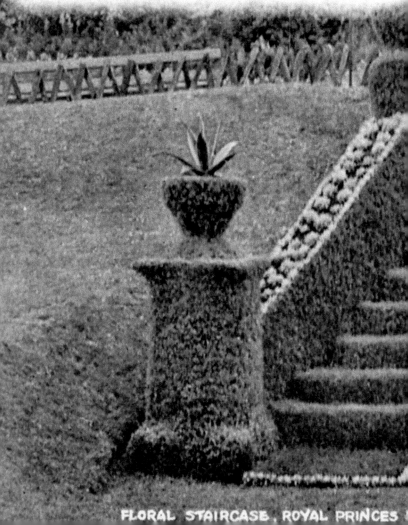

FLORAL STAIRCASE, ROYAL PRINCES

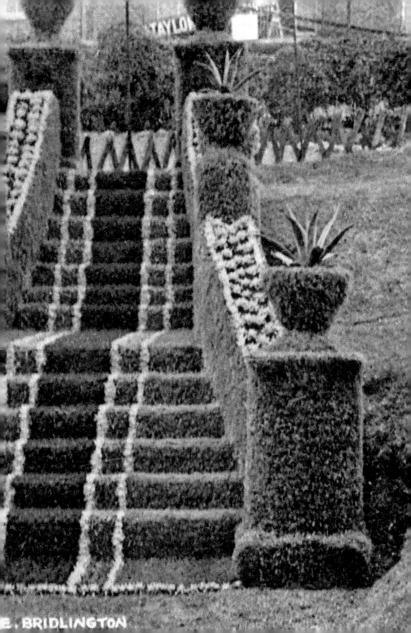

7. LEISURE WORLD

Standing on the former site of the Grand Pavilion and Floral Hall was Leisure World, which was opened on 3 April 1987 and is seen here in the summer of that year, illustrating how tastes in holiday entertainment have changed.

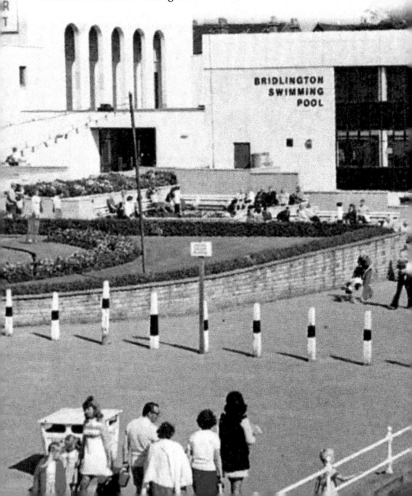

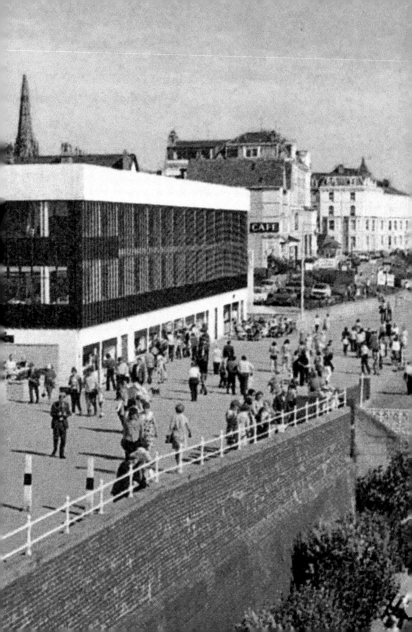

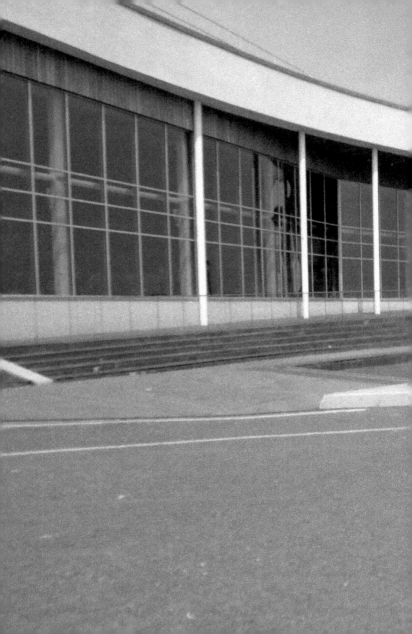

The Leisure World building only had a very short life because it has been superseded by the new Bridlington Leisure Centre, which opened in 2018.

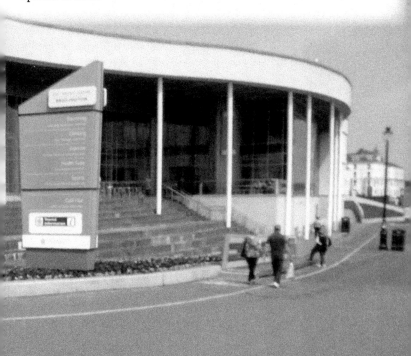

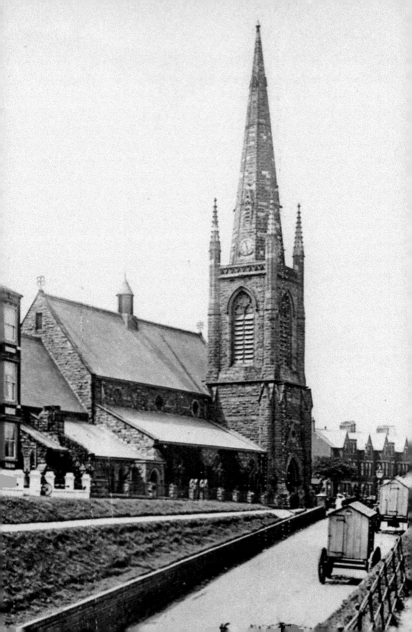

8. TRINITY CHURCH AND CUT

Situated at the Beaconsfield end of the north shore is Trinity Cut, which leads up to the Promenade and is seen here in the late nineteenth century with bathing machines waiting to go down to the beach.

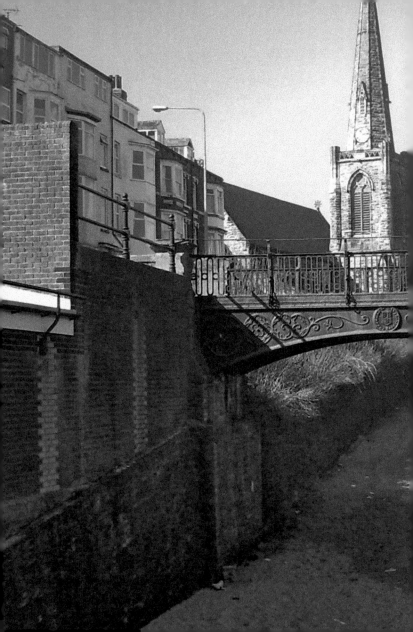

Trinity Cut crosses under a bridge that carries the royal crescent. This bridge is known locally as 'Donkey Bridge', beneath which was a popular spot with courting couples.

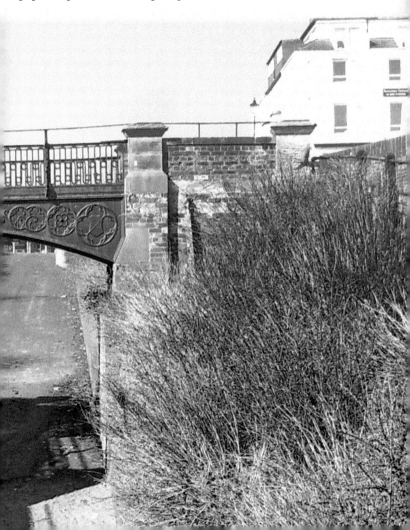

9. THE PROMENADE

The Promenade is one of the main shopping streets in Bridlington. Due to a shortage of building stone, most of the buildings here were built of East Yorkshire bricks, made from local clays. This is demonstrated in this 1971 view.

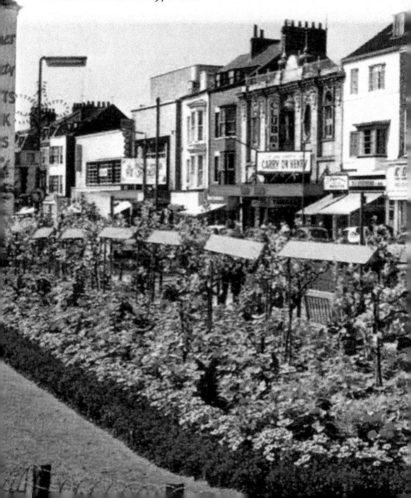

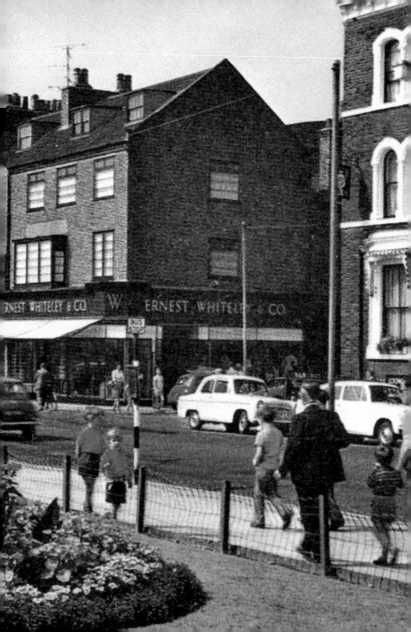

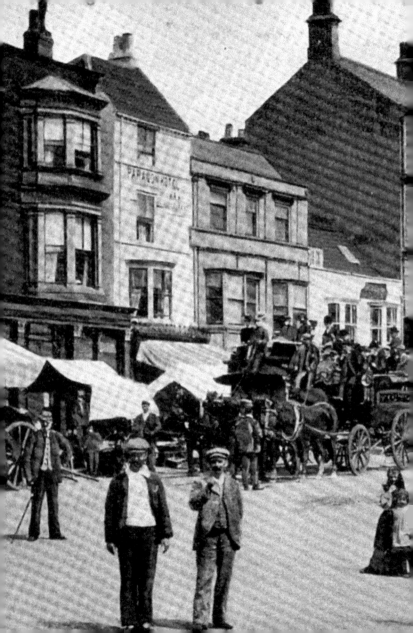

10. PRINCES STREET

An early twentieth-century view of Princes Street. The street is full of horse-drawn buses and carriages in the days before the internal-combustion engine changed everything forever. The street here connects with roads leading up to Quay Road.

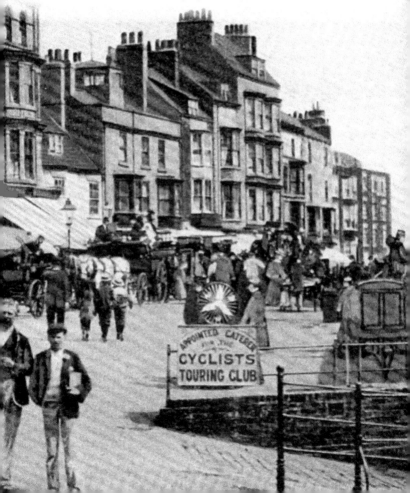

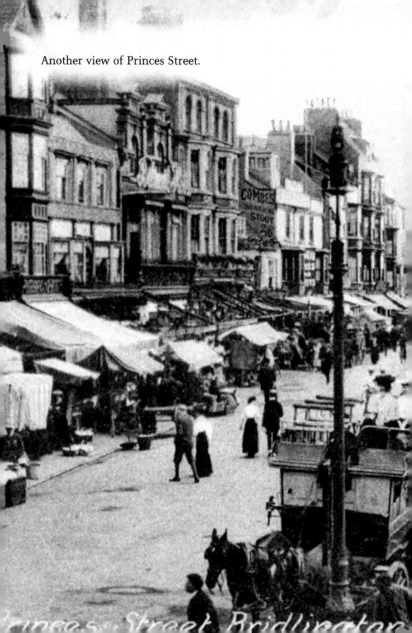

Another view of Princes Street.

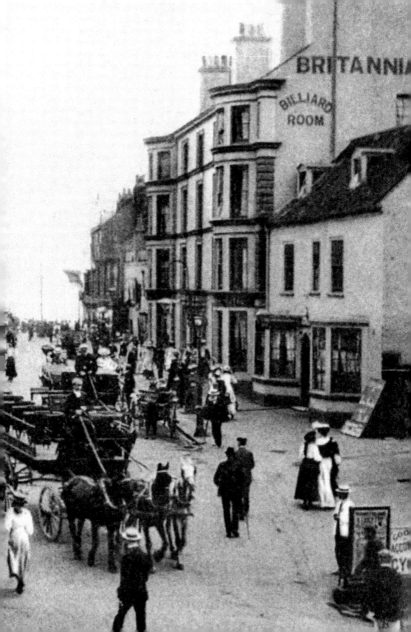

70.15. FLAMBOROUGH ROAD, BRID

11. QUAY ROAD

An early twentieth-century view of Quay Road, an unusually wide thoroughfare for this time. Its uncommon width was to help cater for large amounts of traffic operating to and from the harbour. The houses here are typical of brick properties built at this time. Quay Road connected the quay area with the business district at Old Town.

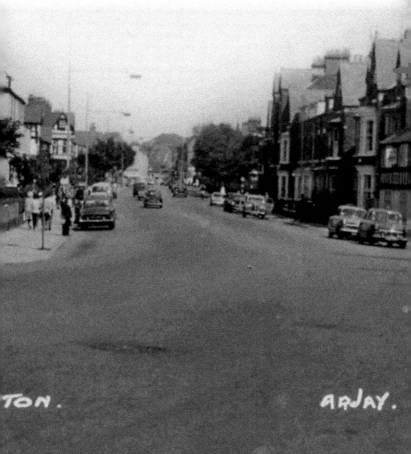

TON. ARJAY.

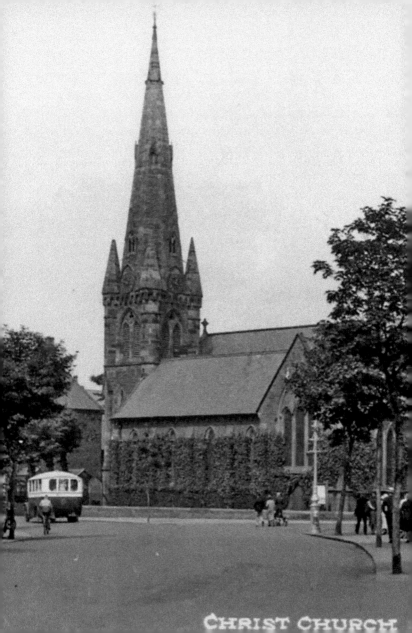

CHRIST CHURCH

12. CHRIST CHURCH

Built in 1840, Christ Church sits at the junction of Quay Road, Prospect Street and Wellington Road. This 1930s view shows Christ Church and the war memorial in its own garden and commemorates Bridlington men who lost their lives fighting in the First World War. Only a few years later and more local men would perish in the Second World War.

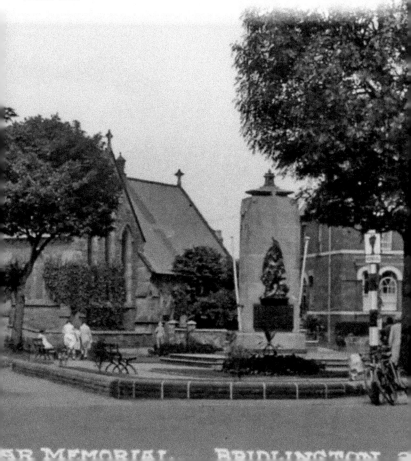

A modern view of Christ Church.

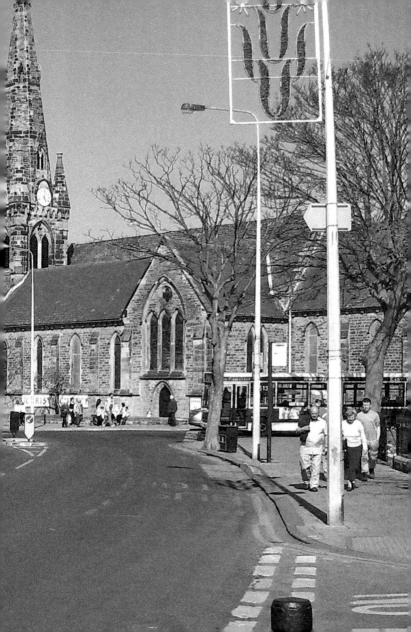

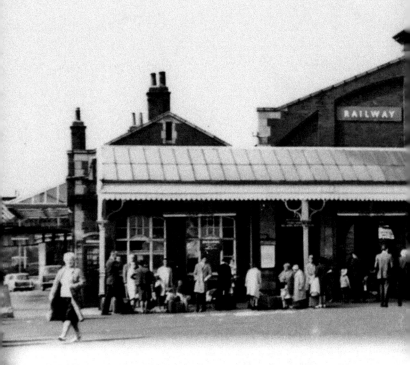

13. BRIDLINGTON RAILWAY STATION

Exterior of Bridlington railway station in August 1967. In 1834 a proposal suggested a link from the Leeds and Selby Railway in West Yorkshire to Bridlington Quay, but nothing came of it. However, by 1845/6 railways approached the town from Hull and Scarborough. The Hull and Selby Railway promoted a line from Hull to Bridlington,

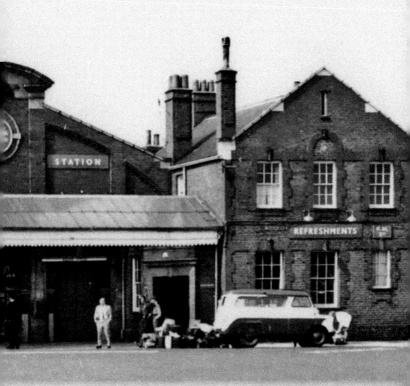

while George Hudson's York and North Midland Railway promoted a line from Seamer (on the main line to Scarborough) to Bridlington, making a connection in the town and creating a through route to the port at Hull. Both were authorised on 30 June 1845. The following year, on 6 October, the line from Hull was opened, to be followed by the line from Seamer a year later.

The railway station in August 1967 with an excursion train about to depart for the West Riding. In the summer months, it was not unusual to see engines from different areas on such trains.

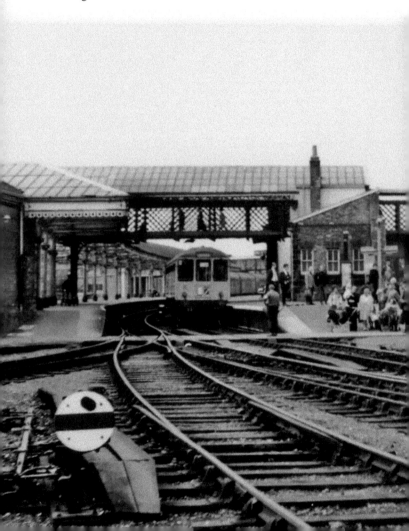

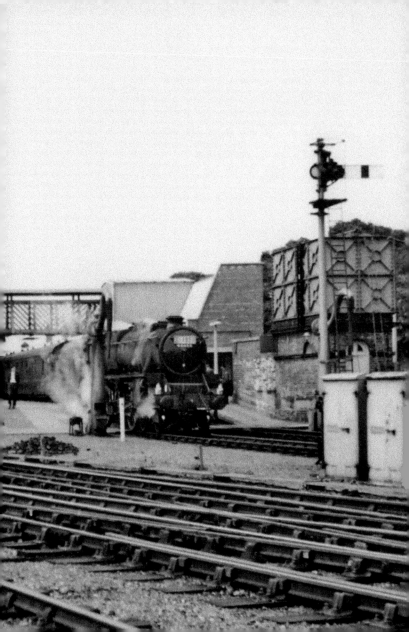

As an important holiday and freight location, Bridlington had its own engine shed, which is seen here in April 1953. The shed here was opened in 1892 and closed in 1958, being finally abandoned in October 1968. A B&Q DIY store now stands on the site.

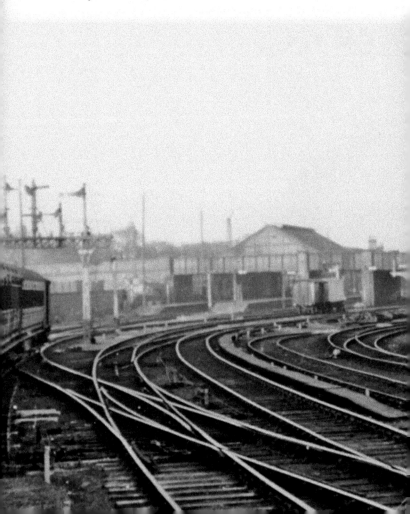

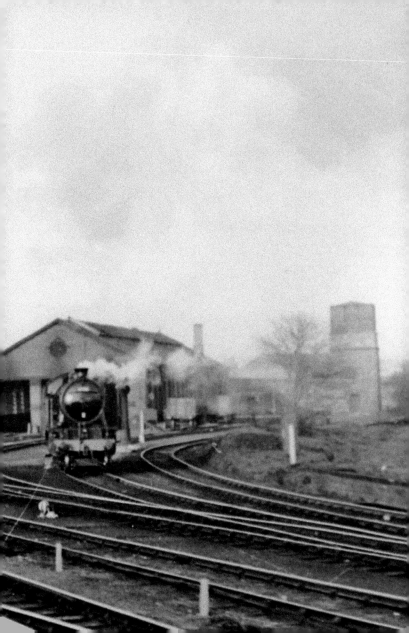

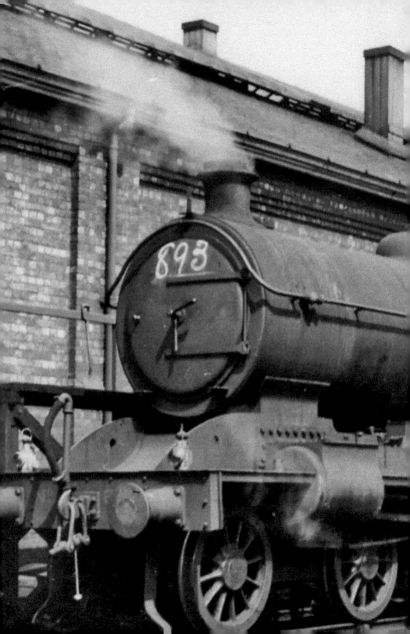

Standing outside the engine shed is ex-North Eastern Railway 4-6-0 in LNER livery, No. 825.

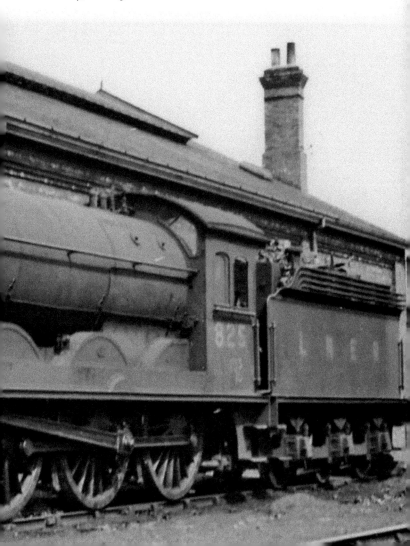

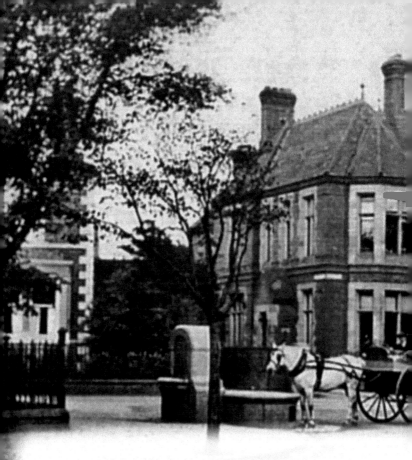

14. LLOYD HOSPITAL

Lloyd Hospital is seen here at the end of the nineteenth century. The hospital was named after Alicia Marie Lloyd, who presented £1,200 to the town to found a dispensary here. Local doctors opposed to its establishment because they thought people would prefer to receive free treatment. The hospital was opened in Quay Road in

1868 and extended in 1875. Plans were later made for a new building at a cost of £1,800, and a plot was purchased in Medina Avenue. This new building opened in April 1876 at a total cost of £32,000. Lloyd Hospital eventually closed in 1988 when the new Bridlington District Hospital was opened. Lloyd Hospital was put up for sale and eventually demolished.

A new Mormon church now stands on the site of the former Lloyd Hospital.

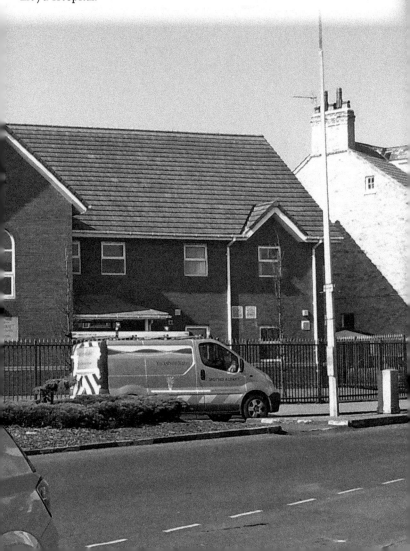

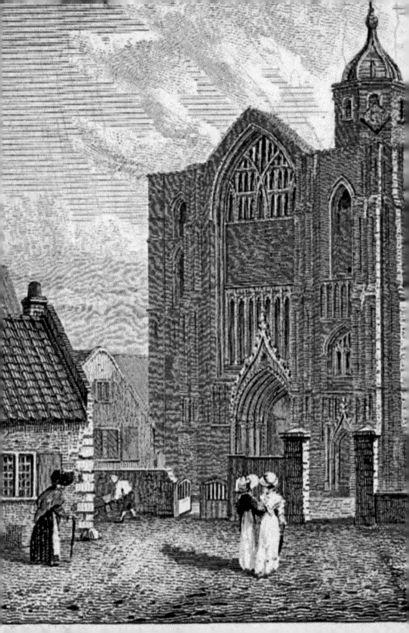

15. BRIDLINGTON PRIORY

Perhaps the oldest part of Bridlington is the priory church, which was built on land given to Gilbert de Gaunt in 1072, a nephew of King Stephen. His eldest son, Walter de Gaunt, founded an Augustine priory on the land in 1133. A charter by Henry I confirmed the role of the priory and successive kings extended it in successive years. King Stephen also gave the priory the right to have a port, which the monks put to good use. Along with the land, King John granted the right to hold a weekly market and annual fair in 1200. Later, Henry VI allowed the priory to have three fairs annually, and it was from this point that the town grew around the priory.

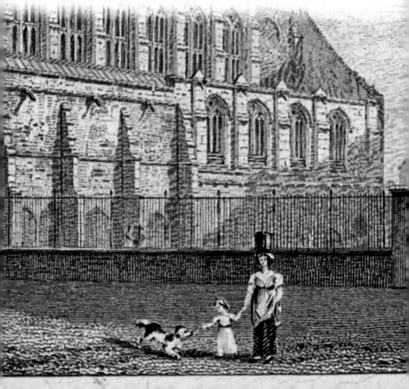

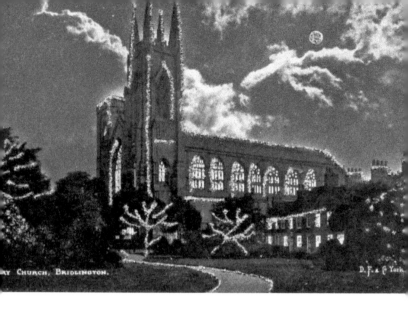

Since the Dissolution of the Monasteries under Henry VIII the priory is now the Church of St Mary. A model of how the priory used to look in its heyday can be seen when visiting. Bridlington even has its own saint, St John of Bridlington (1320–79), the last English saint to be canonised before the Reformation – in 1401. His shrine has attracted many worshipers, including Henry IV and Henry V.

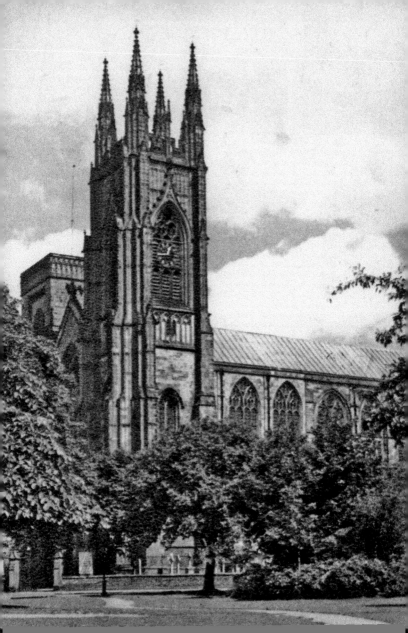

16. THE BAYLE GATE

The Bayle Gate dates back to 1388 and was the gatehouse to the priory. Later it became the prison and manor courtroom, held in trust by the Lords Feoffees, who still meet here. The Bayle is now a museum.

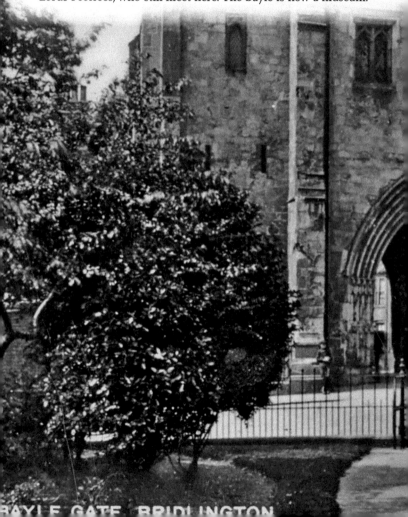

BAYLE GATE BRIDLINGTON

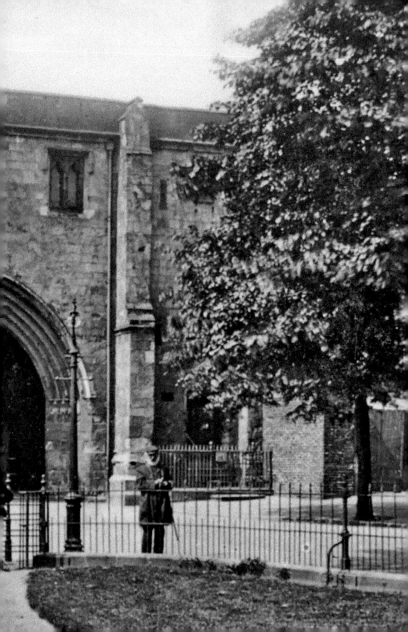

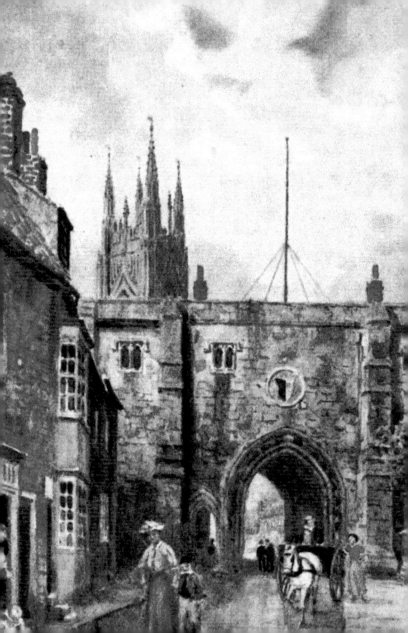

Bayle Gate in the eighteenth century, at a time when cottages were situated on the road leading to the Bayle – these went long ago to create the Church Green. Kirkgate is the road that has replaced the original. After the dissolution the manor of Bridlington remained with the Crown until 1624 when Charles I granted it to Sir John Ramsey, Earl of Holderness. In 1633, he sold the manor to thirteen inhabitants of the town on behalf of the manor's tenants. By May 1636, a deed was drawn up to the thirteen men as Lords Feoffees (trust holders) of the manor of Bridlington.

17. KIRKGATE

A view of Kirkgate looking towards the priory in the late nineteenth century – these cottages replaced the eighteenth-century ones. Since then, Kirkgate itself was moved to create the Church Green.

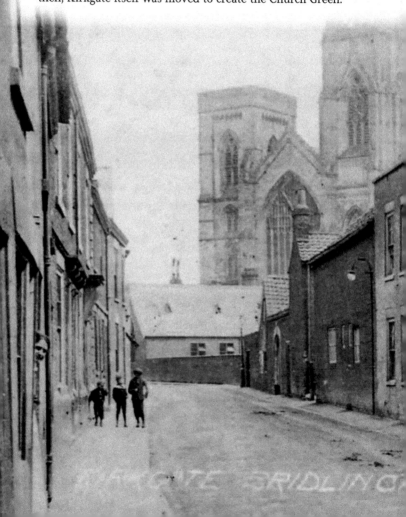

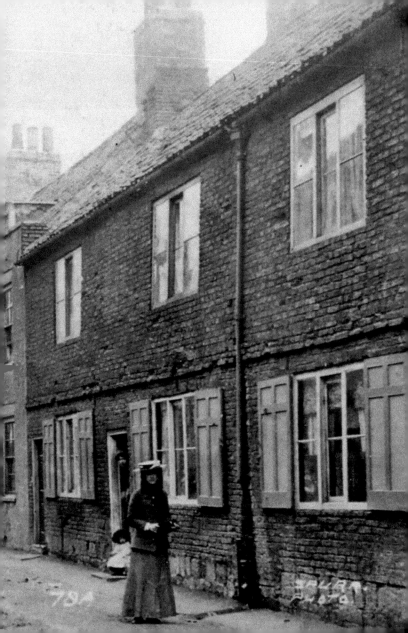

18. THE OLD TOWN

High Street in the Old Town. This was Bridlington's business district and the Georgian shop frontages give some idea of its importance. A convent is also situated on High Street, close to the priory, and it has been suggested that a brothel was once situated directly opposite. Close to Christmas High street is closed to road traffic so that a Dickensian festival can take place. The street was also the setting for part of the *Dad's Army* film of 2016.

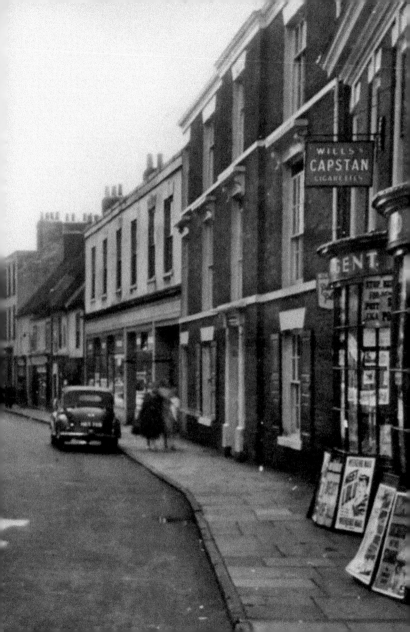

19. MARKET PLACE

Seen here in the 1960s, Market Place was once known as Cross Hill. It was the site of the old market and contains many old buildings. At the junction with Scarborough Road is a flower shop that was once the stables for the local hunt's horses.

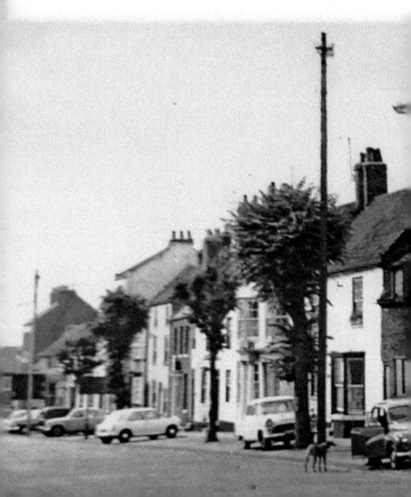

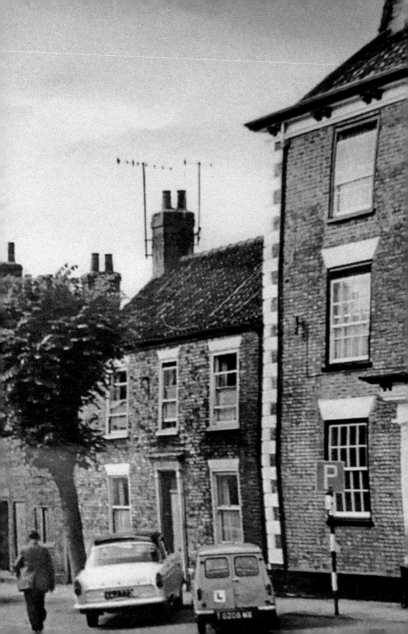

The Packhorse public house on Market Place is seen here in the nineteenth century. A relic of the town's medieval past are the stocks, situated outside The Packhorse, although not visible in this view.

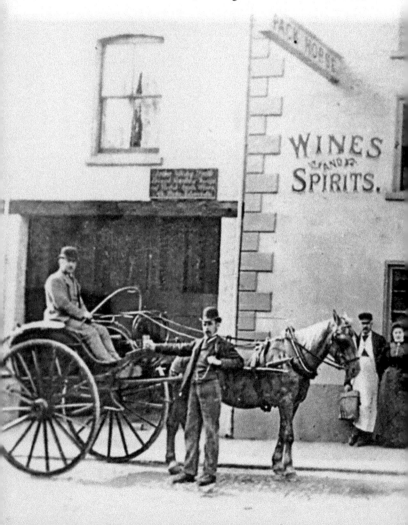

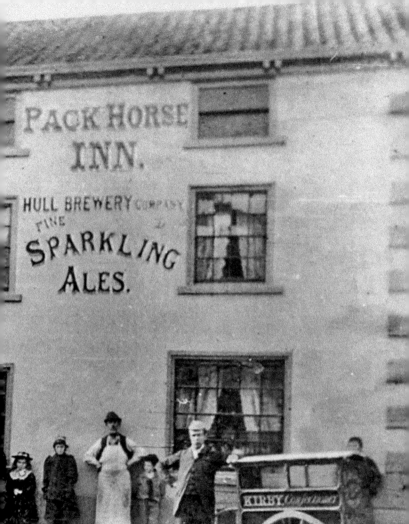

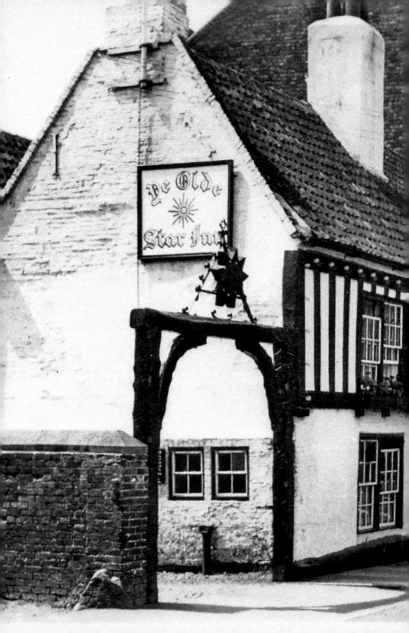

20. YE OLDE STAR INN

Ye Olde Star Inn is seen here in the 1950s, although its history dates back long before. It is part of the character of the Old Town. It has been suggested that the inn is haunted, as many of the Old Town's buildings are reputed to be. A step is situated on the outside of the inn, which was used by ladies to mount their horses for the Middleton Hunt, which was centred here for many years.

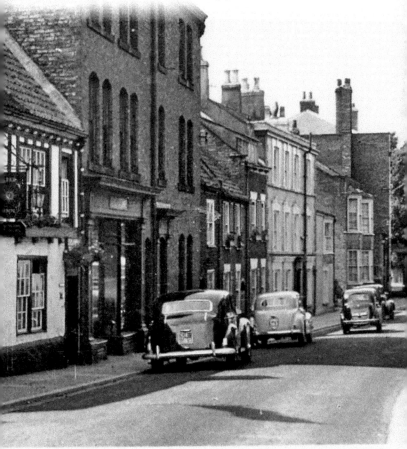

21. THE AVENUE

The Avenue on Westgate in the Old Town was built for the Pickett family in 1714 and was bought by Thomas Pickett in 1760. In 1932, the building became a hospital until it closed when Bridlington District Hospital opened. The building was left derelict until 1993 when it was listed and then converted into apartments.

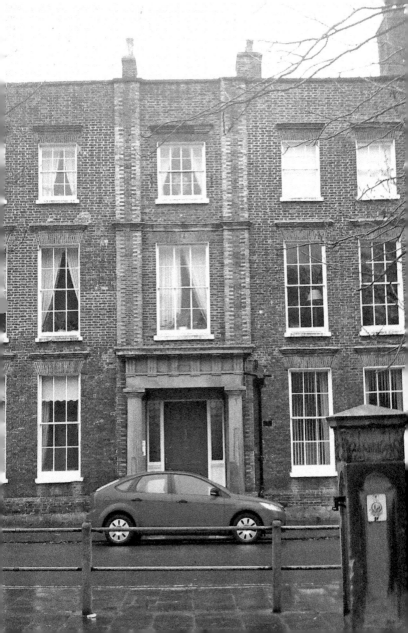

Bridlington District Hospital was opened in March 1988 on the junction of the A614 and Bessingby Road.

ABOUT THE AUTHOR

A native of Birmingham, Mike Hitches is a retired staff nurse living in the North Yorkshire seaside resort of Filey, which lies equidistant between Scarborough and Bridlington. He has also lived in North Wales and Manchester.

Mike obtained a social sciences degree from Bangor University in the 1980s and went on to lecture in sociology at night classes before starting a writing career. He studied for a nursing diploma in the 1990s and went on to specialise in cardiology.

Mike is widowed and has two sons and a granddaughter, who is very precious to him because she is the first girl in his family for three generations.

He still, sometimes, give talks on various local topics and volunteers at a local charity shop and local library.